David Hurn Photographs 1956-1976

David Hurn Photographs 1956-1976

First published 1979 by the Arts Council of Great Britain

Photographs © David Hurn
Introduction © Sir Thomas Hopkinson

Designed by Alan Stewart
Production management by Travelling Light, London
Printed in duotone by Rapoport Printing Corp., New York
Distributed by A. Zwemmer Ltd., 26 Litchfield Street, London WC2H 9NJ

British Library Cataloguing in Publication Data
Hurn, David
 David Hurn Photographs 1956–1976
 1. Photography, Artistic
 I. Arts Council of Great Britain
 779'. 092'4 TR654

ISBN 0 7287 0203 7 Hard cover
ISBN 0 7287 0202 9 Soft cover

A list of Arts Council publications, including all exhibition catalogues in print, can be obtained from the Publications Office, Arts Council of Great Britain, 105 Piccadilly, London, W1V 0AU

Cover photograph: Sarah of Abertillery, Wales

David Hurn
Photographs 1956-1976

with an introduction by Tom Hopkinson

Arts Council of Great Britain

For Siân

I would like to thank all those who, in some way, have encouraged and helped.

Mum and Dad, John Antrobus, Michael Peto, Marianne Braun, Norman Hall, Tom Carlile, Phillip Jones-Griffiths, Bill Jay, Patrick Ward, Don McCullin, Sergio Lorraine, Alita Naughton, John Hillelson, Ian Berry, George Rodger, Henri Cartier Bresson, Elliott Erwitt, Charlie Harbutt, Burk Uzzle, Leonard Freed, Barry Lane, Isabel Hitchman, Peter Jones, Josef Koudelka, Keith Arnatt and John Charity.

To those I have left out I apologise. You will know of my appalling memory and I trust you will understand and forgive.

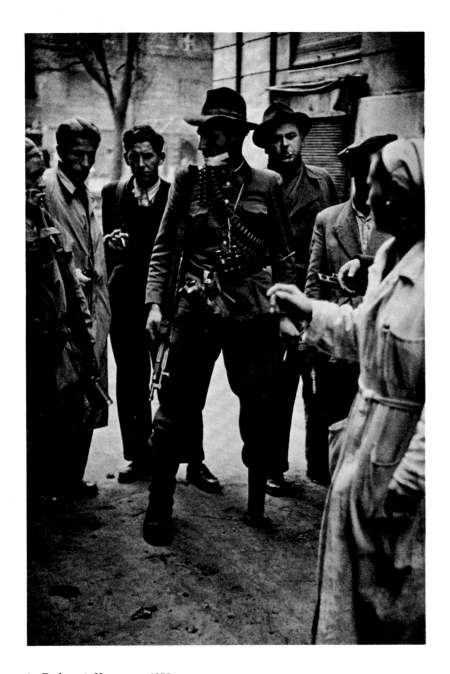

1 Budapest, Hungary 1956

David Hurn and his work by Tom Hopkinson

The special quality of David Hurn's pictures comes from his having discovered how to apply the methods of photojournalism in a new way and in a different field.

His work, like that of all good photojournalists, is directly related to contemporary life, and, being firmly rooted in the everyday world, his pictures have none of that hollowness of much of the photography produced in support of intellectual theories and ideas. They are also completely without contrivance or pretension. Communication in a David Hurn photograph is direct, nearly always enjoyable, and often humorous. No page of tortuous explanation is required to release its meaning. One laughs first – and then starts to reason out just why one did so.

The everyday world of David Hurn is a world of men and women, and essentially of children. It is not one consisting solely of abstract shapes, peeling walls, or the corners of abandoned attics; but neither is it, like so much photojournalism, a world of over-emphasis. The men inhabiting it are not public figures, but inconspicuous and unimportant, the women are anything but glamorous, and the children are not sweet; far from trying to charm the viewer, they are usually involved in some private game or fantasy to which no clue or means of entry is offered.

What is most extraordinary is that however private or personal the subject – a drag ball, a couple of stripper friends back-stage – Hurn's pictures never convey an impression of having been stolen; it is as though their subjects had given a general consent to being photographed and then forgotten all about it, so that even the most intimate scenes carry no suggestion of intrusion or betrayal. The reason for this candour of acceptance lies, however, not in the subjects but in the photographer and his total lack of either prurience or malice. He reveals but never exposes; laughs but never ridicules. *This is the human lot, the human condition. I'm a human being, and you who are looking at the pictures are a human being too*. That is the simple but sufficient message of his photographs.

From his years of experience as a photojournalist David Hurn has learned another principle of profound importance – to allow for the element of chance. The photographer who tries, as many do, to control every element in a picture, ends up photographing his own mental images, and these can indeed have a validity. But the photographer who has the courage to involve himself with the flow of life must not try to visualize beforehand precisely what he expects; his role is that of the hunter who waits to see what, if anything, breaks from the undergrowth or darts down from the treetop. In many of Hurn's best photographs it is evident that the scene could not only not have been contrived, but – like the elderly man at a dinner party trying to capture a balloon – could never have been imagined as likely to occur. His training in photojournalism, however, has taught him not only to seize the instant when it offers, but – far harder – to wait and wait and

wait when it does not.

And this is, indeed, the way he operates: *I consider myself as simply a recorder of whatever I find interesting in the world about me. I have no desire at all to direct or stage-manage ideas. People to me are always more interesting than anything else, for people are always liable to do something startling, to make a surprising gesture, to reveal their inner feelings in some quite unexpected way. If a photographer wants to control anything, he cuts himself off from life – he is trying to* produce *the action as well as to record it.*

Unlike the majority of photojournalists, David Hurn does not choose great events as hunting grounds or eminent personages as targets. He likes to attend an 'event' of some kind, which will guarantee a gathering with some common interest or purpose, but these events are modest, of no significance except to the participants. You could call him a haunter of small-time community activities, at a level which might rank for a paragraph in the local weekly but fall far below national newspaper or television coverage . . . flower show . . . a church outing . . . a village fete.

From such commonplace activities – at the mere mention of which professionals recoil, and which those who consider themselves 'creative' photographers would dismiss as meaningless – David Hurn extracts impressions so slight, but at the same time so significant, that in looking at them one inwardly both laughs and weeps for the whole human race. And these impressions owe nothing to any unexpected angle or originality of approach; he tackles his subject head on, but with a kind of affectionate detachment which is entirely his own, and is, for me, the hallmark of his work.

When I go to an event and shoot two or three films, the scenes which survive most strongly in my memory are nearly always those which produce the best pictures when I go through my contacts later on. If I can't remember anything in particular, then it's almost certain there'll be no good pictures.

I'm just the opposite of those dominating characters who rush in and take charge of everything . . . say where every animal on the farm has got to stand and just what all the people in a situation must be doing. In fact, I hide behind my camera. This both helps me conceal my nervousness, and also allows me to be present where I should hardly dare to penetrate without such defence. You know, when I start to take pictures I have often the odd feeling that I'm looking in on a world of complete confusion. I start to move around, and first one detail, then another, catches my attention. I record them, and gradually there starts to emerge some sort of plan, some order out of the chaos in the form of a few photographs, and when this starts to happen I feel tremendous satisfaction.

Does he, I asked David Hurn, find photography difficult?

The key to everything is that one must have a genuine feeling for one's subject, a respect for the people involved, often almost an affection, and the

wish to record exactly what one sees. There's a sense in which everyone already has the qualities for a good photographer. The mother who takes snapshots of her baby with an Instamatic has the love and concentration, the sincerity to take good pictures. Many people take excellent photographs of their families and everyday surroundings without the least attempt at being 'artistic' and seventy years later their simple everyday shots become collectors' items.

Difficulty comes in at the point where the beginner wants to become more than a recorder of what he loves, and tries to take 'better' photographs. Simplicity and naturalness disappear, and every kind of trick and artifice creeps in. Concern shifts from the thing photographed to the manner in which it is done – shooting through holes or at funny angles. All complete boredom! Photographers should forget about composition and open themselves to feeling, to the impression the scene before them makes. Record honestly what's there, and you don't need to bother about the way you do it.

But surely, I suggested, composition is important?

Yes indeed, but thinking about it isn't. My approach to taking a picture can be put quite simply. I look at the subject. I concentrate entirely upon it, and then move around to find the position which reveals it most completely In this way all the 'composition' is done for me.

What are his views about equipment?

I work almost entirely in black and white. I've reduced my equipment to the minimum necessary for what I try to do. I used to work with just three Leicas, but have changed now to Olympus, with 28, 35 and 50mm lenses. I use the 35 for horizontal pictures and the 50 for verticals, since with the 35 you're apt to get distortion at the top or bottom of the picture – the feet or heads – or else you're obliged to keep bending at the knees. The 28 I use in order to include more in a shot when I can't move further away.

When my films are developed I spend a long time on them, looking through them closely, again and again. I mark them with different coloured Chinagraph pencils, each colour having some particular significance, go once more through those I've marked, and decide finally which ones I'll have printed. I do a good deal, though not all, of my own printing, but I always make prints which have been asked for by collectors.

How does David Hurn regard the work of other photographers, and are there any he particularly admires?

When I look at the work of someone new and unfamiliar, I ask myself three questions!

1) What was the photographer trying to do?

2) Has he/she done what was attempted?

3) Was it worth doing in the first place?

The last question rules out quite a lot of what I look at, but at the same time I find that the way I answer the question keeps on changing, no doubt because I myself and my own outlook keep on changing.

The photographers I especially admire are the Americans – Weegee and Lewis Hine, and the turn-of-the-century Englishman, Paul Martin. Of my contemporaries, I look with awe on the achievement of André Kertész, and regard Henri Cartier-Bresson and Bill Brandt as among the giants. Cartier-Bresson is unique! Think of it this way – he never photographs the exotic, always the ordinary. Essentially he is always doing the same thing – which is just to walk down Oxford Street, any Oxford Street. But Henri walks down it and comes back with another of his wonderful pictures, and nobody else can do the same! There must be more people imitating him – more going about trying to take Cartier-Bresson pictures – than anyone else in the world, and yet every one fails to do what he can do.

Of those around my own age, I admire Elliott Erwitt, Lee Friedlander, Burk Uzzle and also Donald McCullin for his courage and his revelation of the violence and tension of our age. Philip Jones-Griffiths is another great photojournalist – his 'Vietnam Inc.' is the most convincing record of a war I know. Ian Berry can tackle just any subject with complete honesty and penetrate to the essentials. Also Josef Koudelka, whose dedication to his work is almost frightening.

Though what attracts me personally is always the human aspect, I've come also to appreciate other kinds of work provided it's done with sincerity and commitment – the scientific photographs of Harold Edgerton, for instance, or Stephen Dalton's insects in flight. Dalton is so much in love with his insects that he pushes his record of their activities to a quite extraordinary height of achievement.

So who, or what, does David Hurn work for nowadays?

What I work for nowadays is almost entirely myself. I hardly do anything for international magazines, or for the Sunday colour supplements. They don't after all, live in the same world. They live in a world where everything's larger than life, and everyone in it has to be blown up to seem cleverer, richer, more successful, more beautiful and seductive than they really are. They're trying to substitute their own fantasy world for the everyday one – and I'm not interested. Nor am I the least bit interested in 'illustration photography' – taking one or two pictures to illustrate an article some writer has already produced.

I'd sooner work for newspapers, or for smaller magazines where my pictures don't get shown so well and are not seen by so many people, but there's more basic honesty in the way they're used. In fact I prefer to shoot pictures I want to shoot, even if I have to endure the disappointment of their not being published . . . But I'd like one day to meet an editor who sits down and discusses with you just what you want to do, and what would be the best way to set about doing it.

David Hurn is a citizen of the world, Welsh in origin. A journalist (French, and female) described him as 'of medium height with dark chest-

nut hair and beard'. To my possibly more disinterested gaze, he appears to have black hair and to be clean-shaven. He is lean, and rather pale; dresses – if that's the word – in jeans which have evidently been washed frequently in mountain streams and dried by being beaten against rocks. In winter these are topped by a padded car coat consisting entirely of pockets – one side holds two or three cameras, while into the other he can easily slip a couple of volumes of the Encyclopaedia Britannica for rapid reference . . .

His cast of mind is a stimulating blend of the spiritual or mystical and completely down-to-earth. Though he operates by intuition, he analyses afterwards exactly what he did and why. He is alert, punctual as all journalists have to be, and possesses the gift – not common, if I may dare to say so, among photographers – of being able to talk lucidly and interestingly about his work. His talking voice, like so many in Wales, has a wide range of tones, and sounds as though he might have made a singer. He never drinks or smokes, eats whatever happens to be there, and appears even to enjoy hamburgers or custard. He is acutely aware of what goes on in his surroundings, while being almost entirely indifferent to their comfort.

He was born in 1934, a family's only son. His father, fighting the battle of the 1930's against unemployment, worked for a time for London Transport. Then when the war came, he joined the commandos and moved rapidly up from the ranks to become a major. As a boy David went to school in Cardiff – *I always look on Cardiff as my home town* – and soon developed into an athlete and rugby player. His intention was to become a vet, and he hoped that he might get the necessary education by way of the army after he had done his National Service.

In 1954 the army sent him to the Royal Military Academy, Sandhurst, with the idea of getting both a whole-time military man and an army athlete out of him, and Hurn did play rugby both for Sandhurst and the Wasps, ran the mile with success and played most of the other games available in a well-equipped sporting centre. But he also started taking photographs. This arose, not out of any artistic impulse, but from the very natural desire to get out of the place at night – a privilege allowed to those who joined the photographic society, since the darkrooms were outside the college.

My very first reportage was on the daily life of my army companions, and what I saw through my viewfinder made me profoundly pacifist. Soon David Hurn left Sandhurst, and after a short spell trying to sell shirts for Harrods, he launched out as a professional photographer by joining an agency called Reflex, whose speciality was taking pictures of the Royal Family: *However, I became fed up with sitting on my backside waiting for royalty to get up off theirs*, and in 1956 his opportunity arrived. He went out to Budapest to photograph the Hungarian Rising and its suppression by the Russians. LIFE magazine used his pictures, and his career in photojournalism was

launched. Before long he was travelling all over the world, working for the OBSERVER, LOOK, the SUNDAY TIMES, ILLUSTRATED and many others.

In 1966 he was invited to join Magnum, most renowned of picture agencies, and in 1971 was awarded the first Welsh Arts Council grant ever given to a photographer, to allow him to make a prolonged picture essay on his own country, Wales. This in turn led to his leaving London and going to live among the hills of Wales, at Tintern in a particularly beautiful bend in the Wye Valley, and also to an entirely new turn in his career. In 1974, after much discussion both with the college authorities and the Welsh Arts Council, he set up at Newport, in Gwent College of Higher Education, a course in photography on lines and with aims completely different from those elsewhere. *All photographic courses had one thing in common – absolutely no connection with the outside world!* After five years, the Newport course is proving itself through the work done by those who have taken it, and the growing number of students applying for admission.

During the last nine years, as his reputation spread, David Hurn has had an impressive series of exhibitions of his photographs in London, Paris, Toulouse, New York, Sao Paulo and many other cities. In 1975 he received the Kodak Bursary, and in 1978 his work was included in the exhibition 'Images des Hommes' in Belgian cities among that of only eighteen contemporary European photographers. And now, in 1979, he has become the first photographer ever to be given one of the important and valuable United Kingdom-United States Bicentennial Fellowships which are open to men and women of achievement in virtually every field of art.

What I am intending to photograph is Arizona – the size of Britain, one of the largest, least-photographed of American states. And what I'm particularly looking forward to is the quality of the light, which is hard and dry. Arizona is the driest state of all – it's supposed to rain on only four days in the year. It's completely landlocked, but it has the largest number of boats per head, the highest fountain and the best surfing – on a lake which is kept stirred up by a wave-machine. It even has London's old London Bridge.

'You'll be away for a full year. What will you be missing most?' I asked.

Apart from my family and friends, what I shall miss most is going to watch Cardiff City play football on Saturday afternoons. D'you realize they've just won four matches on the trot? There probably isn't anyone alive anywhere who can remember when that last happened. No such disastrously unsuccessful team has ever had such a loyal supporter . . . I used to ring up from Rome on a Saturday to hear how they'd got on . . . Now, I suppose, I'll be ringing up from Tempe, Arizona.

So – a wide range of interests. A nature adaptable, but sure of its direction. A generous outlook on the world. An impressive achievement. And still not yet forty-five.

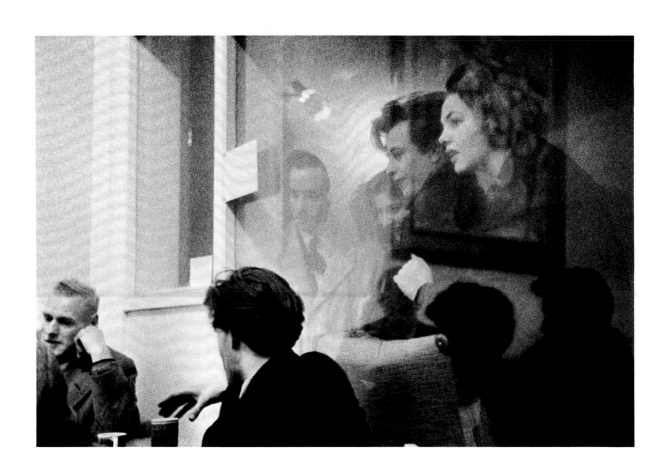

2 London, England 1957

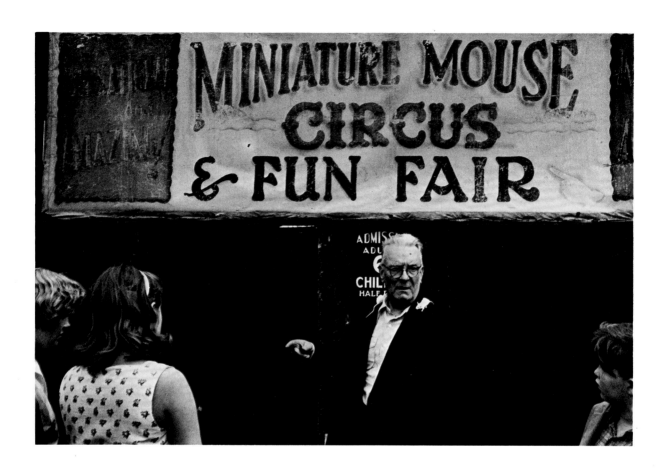

3 London, England 1958

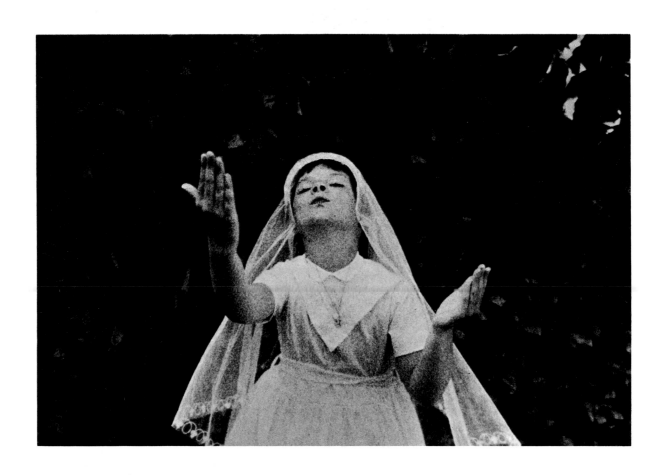

4 London, England 1959

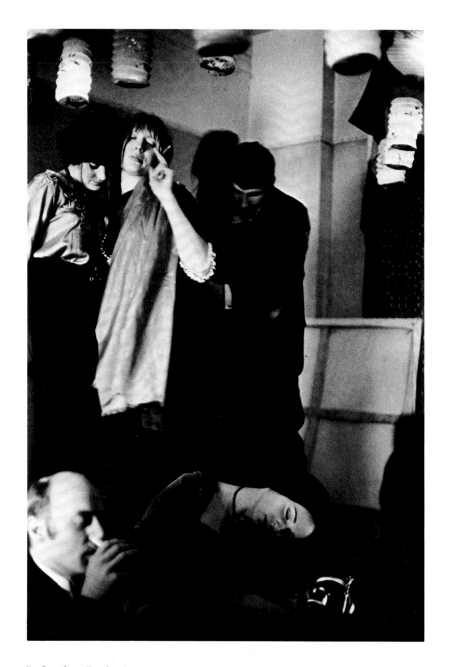

5 London, England 1960

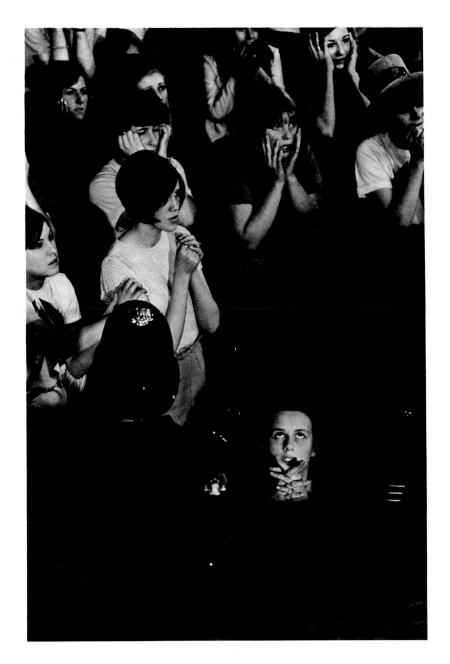

6 Birmingham, England 1962

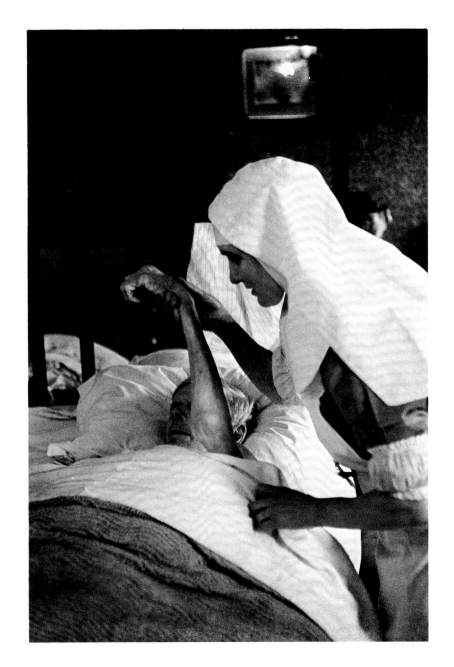

7 London, England 1962

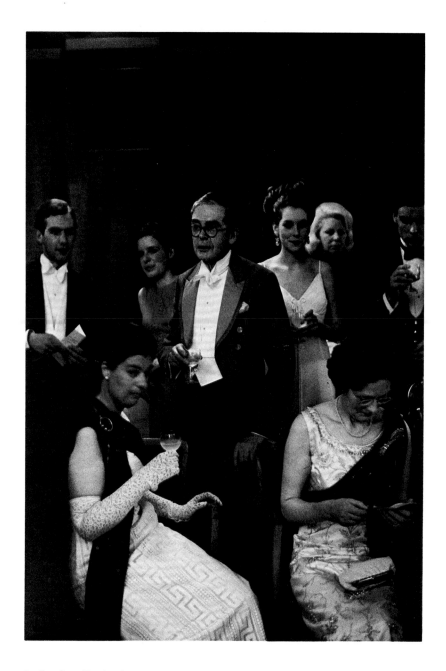

8 London, England 1963

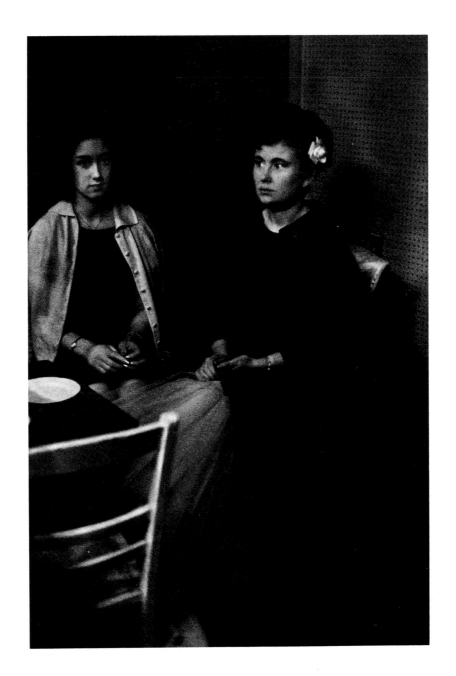

9 London, England 1963

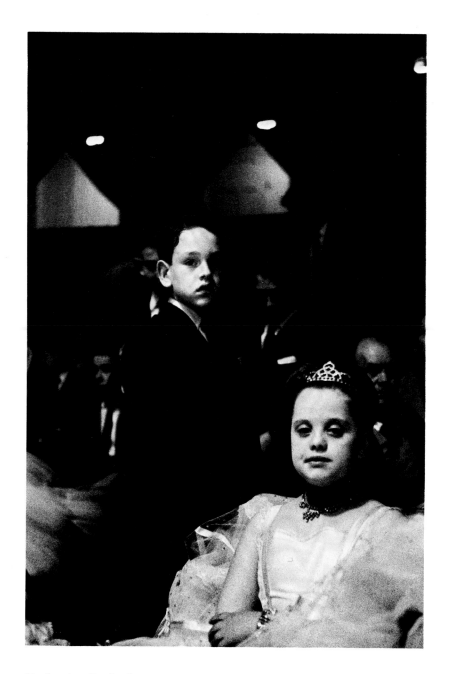

10 London, England 1963

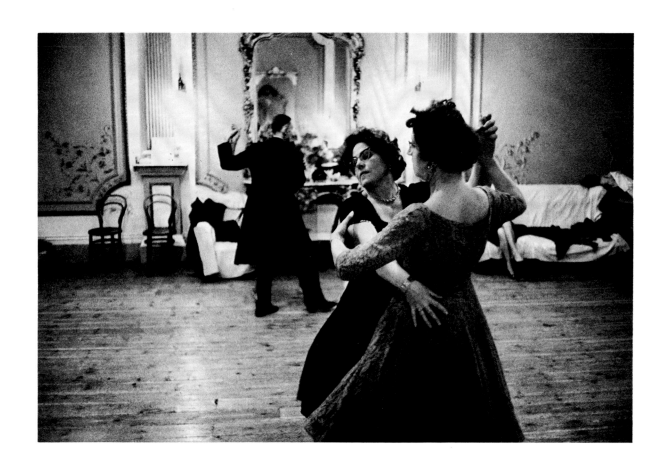

11 London, England 1963

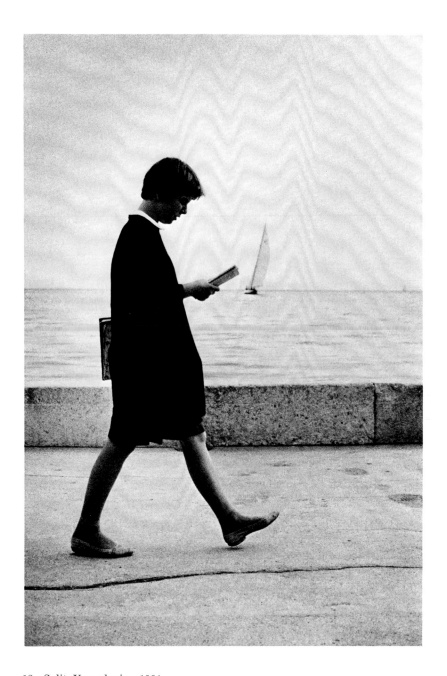

12 Split, Yugoslavia 1964

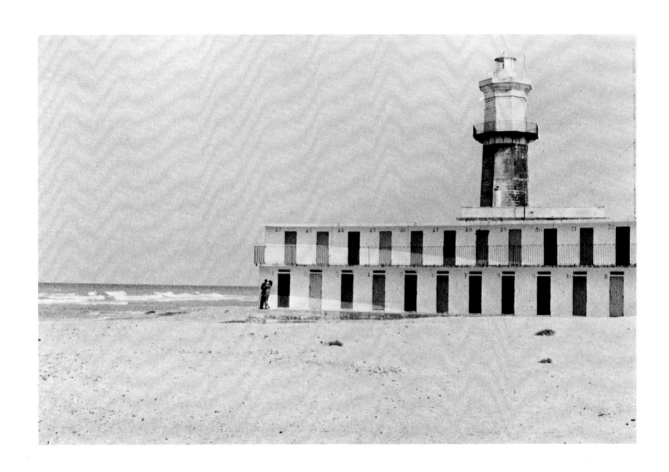

13 Lecce, Italy 1964

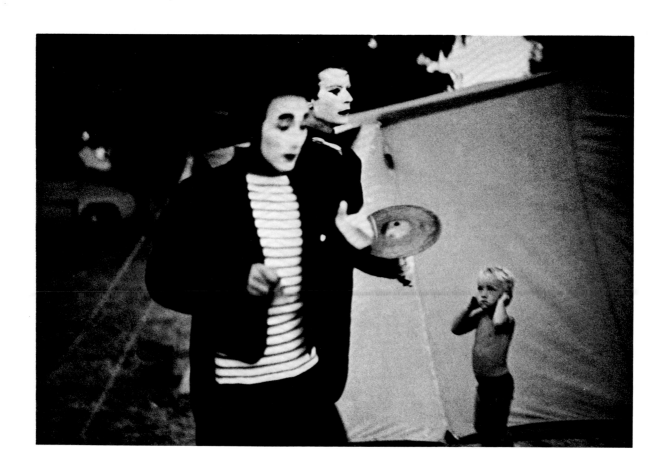

14 St. Tropez, France 1964

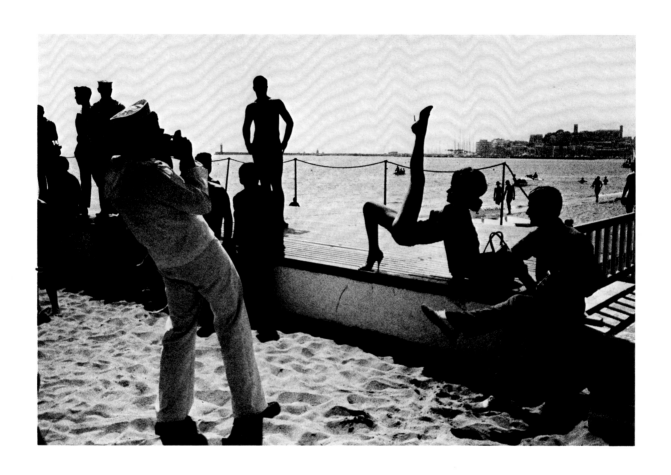

15 Cannes, France 1964

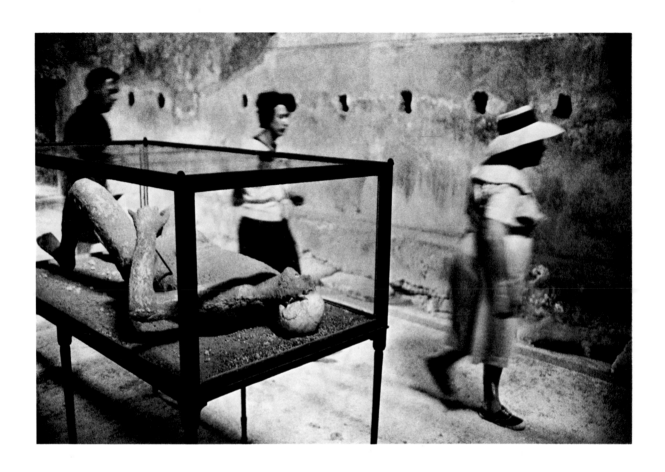

16 Pompeii, Italy 1964

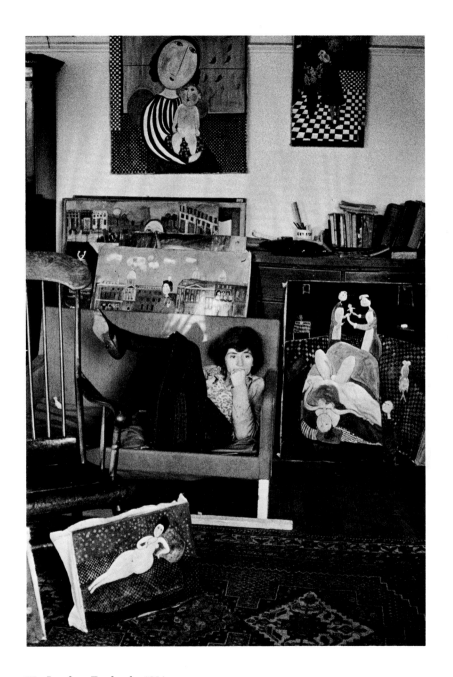

17 London, England 1964

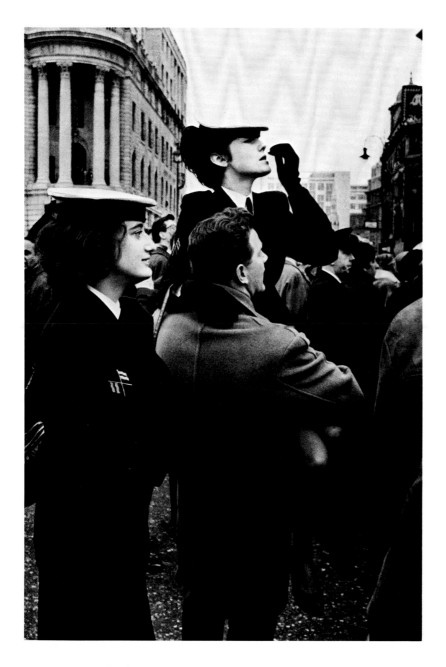

18 London, England 1965

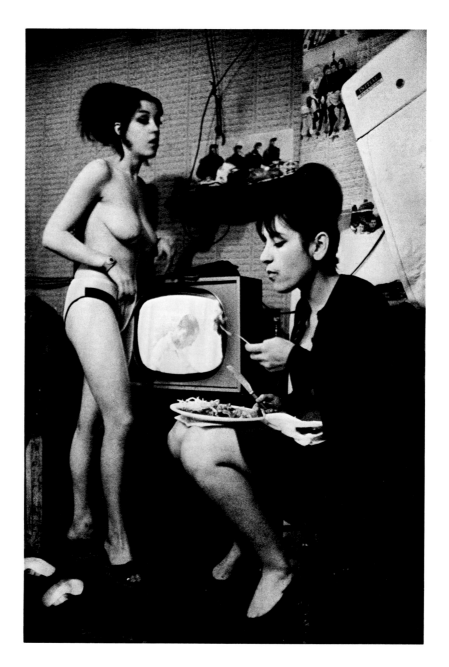

19 London, England 1965

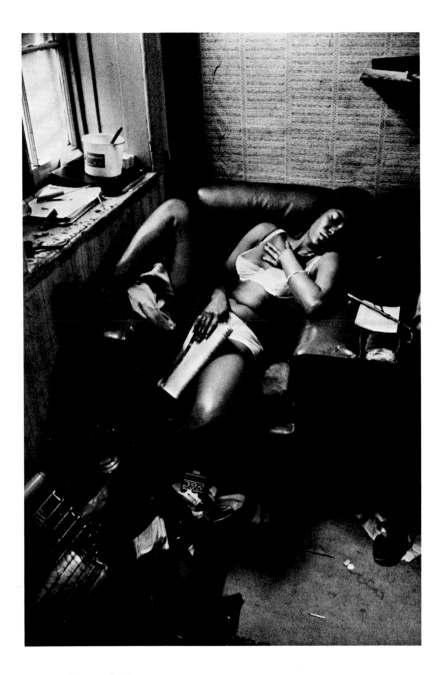

20　London, England　1965

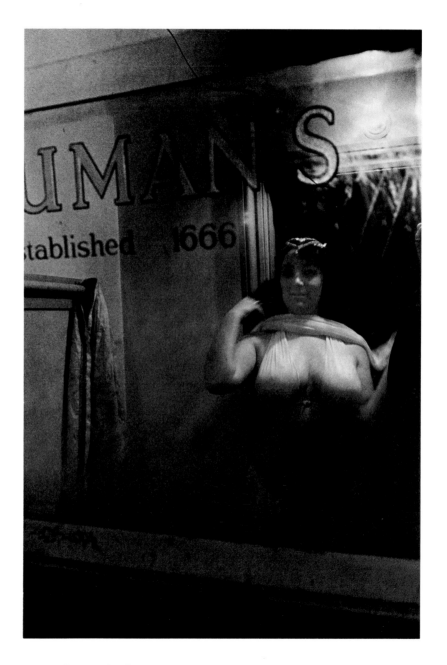

21 London, England 1965

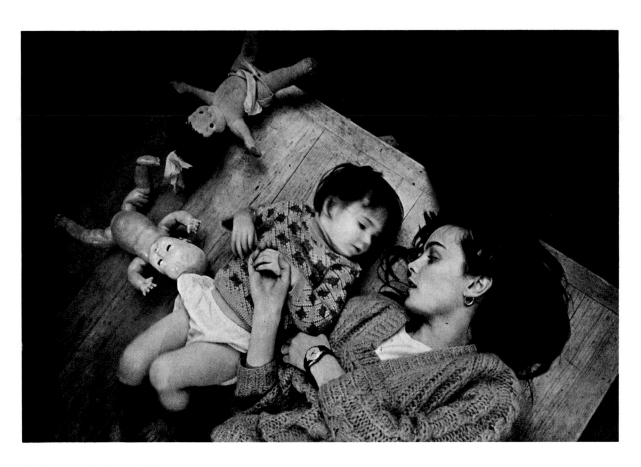

22　London, England　1965

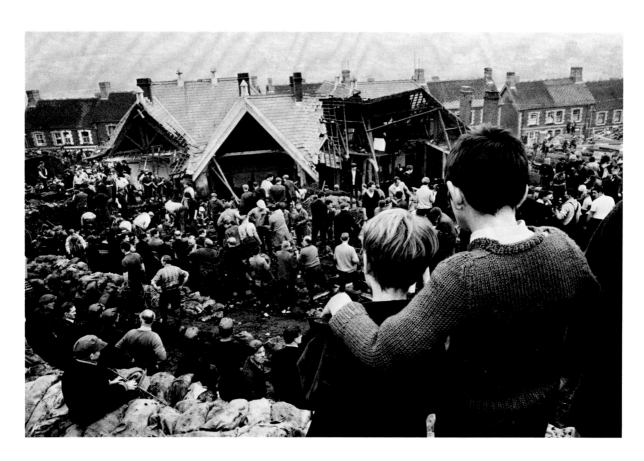

23 Aberfan, Wales 1966

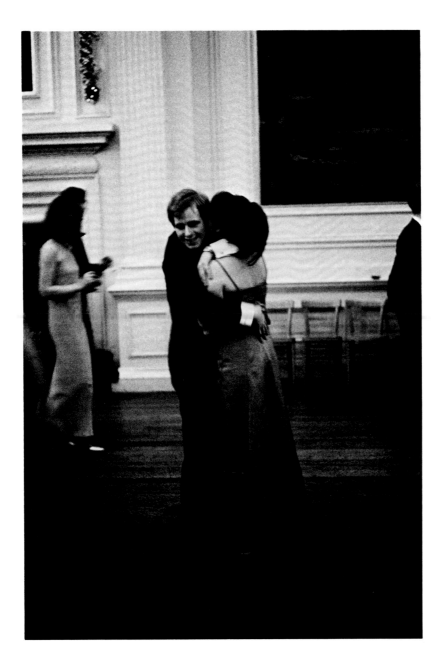

24 St. Andrews, Scotland 1967

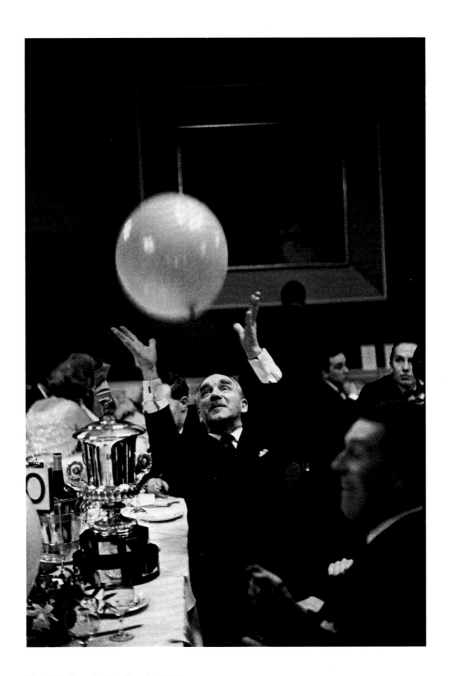

25 Edinburgh, Scotland 1967

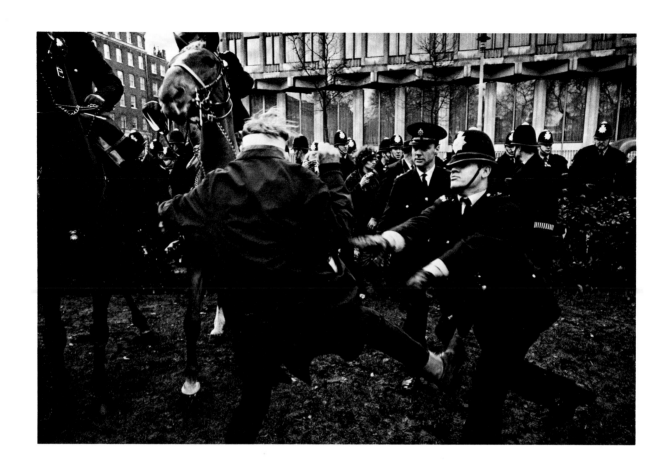

26 London, England 1968

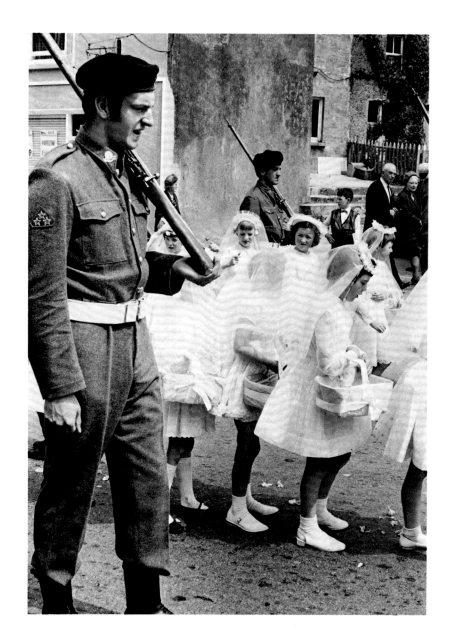

27 Kenmare, Ireland 1968

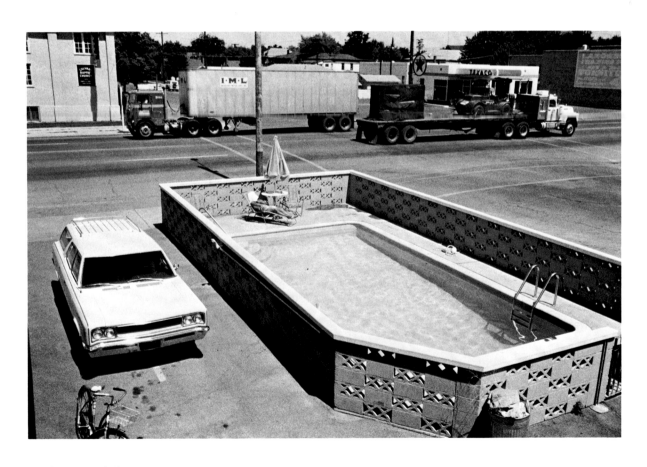

28 Oregon, U.S.A. 1968

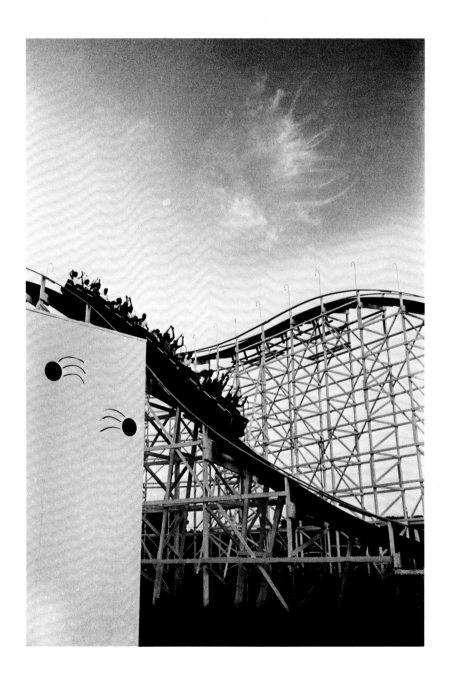

29 Cincinnati, U.S.A. 1968

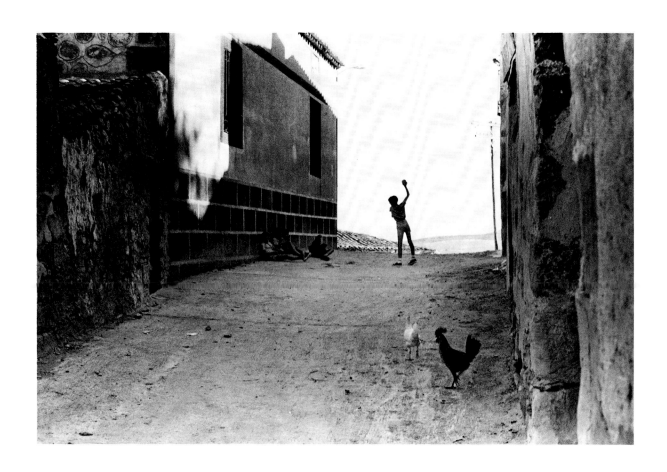

30 Signenza, Spain 1969

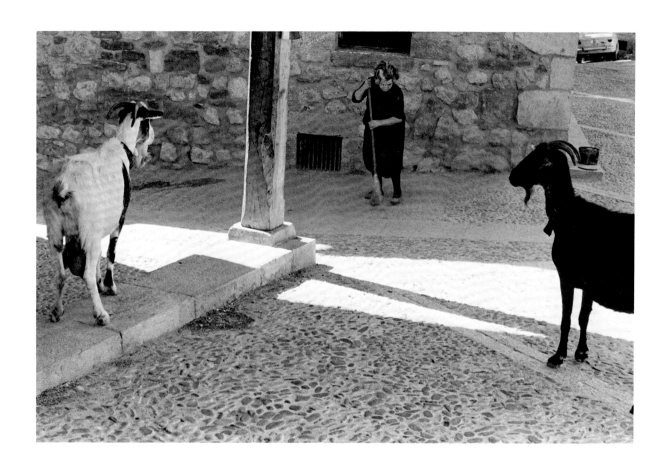

31 Atienza, Spain 1969

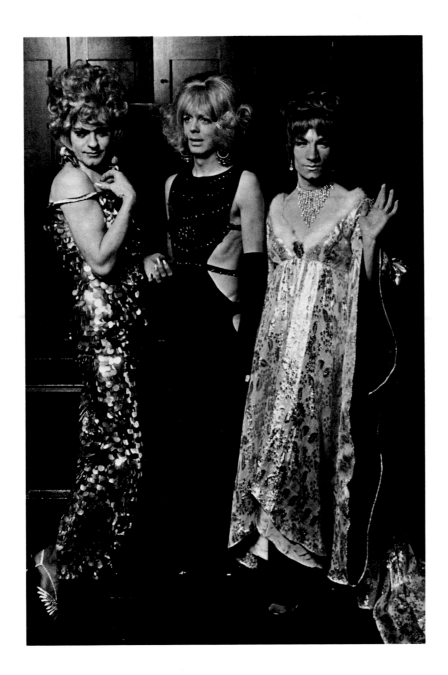

32 London, England 1969

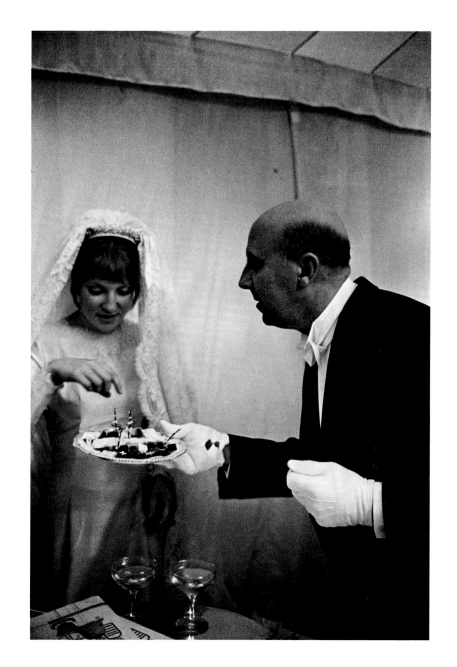

33 London, England 1970

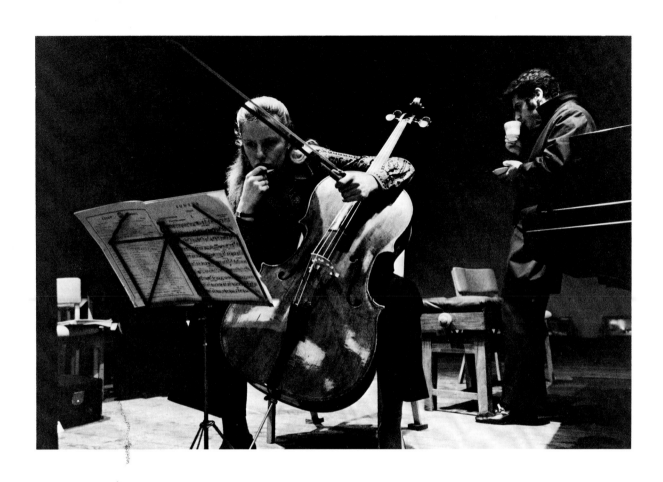

34 Monmouth, Wales 1970

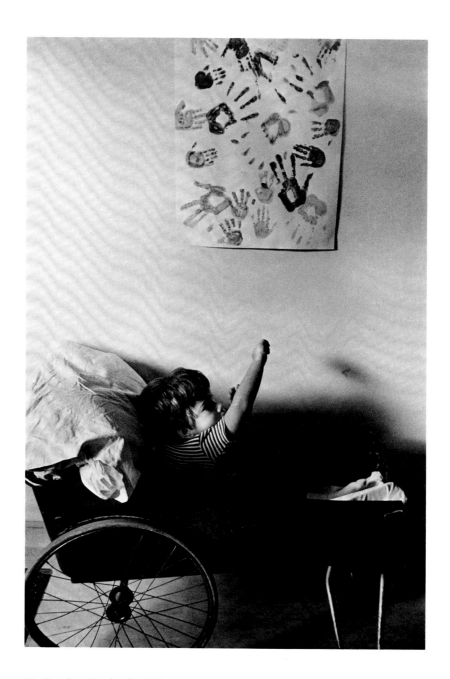

35 London, England 1970

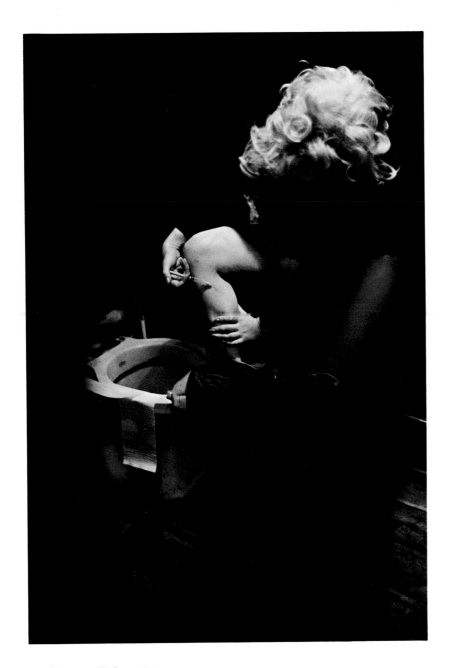

36 Swansea, Wales 1971

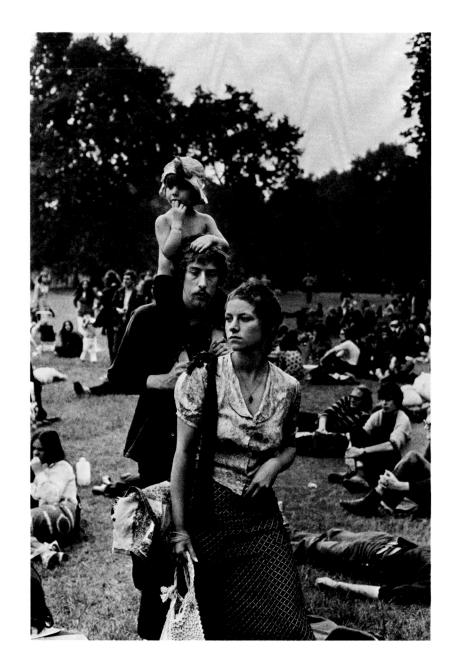

37 London, England 1971

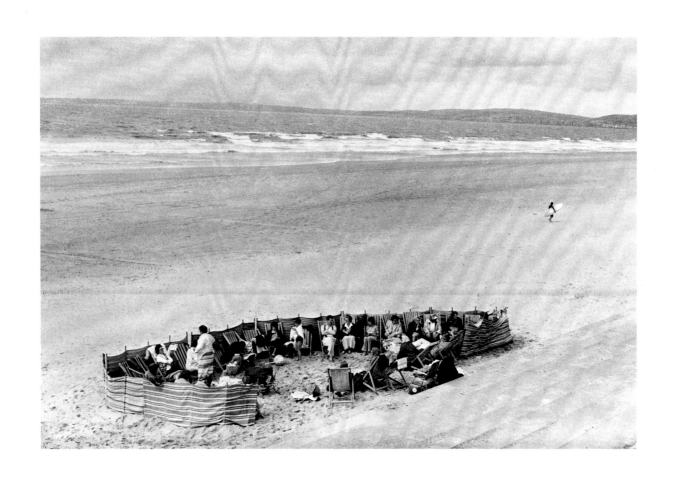

38 Aberavon, Wales 1971

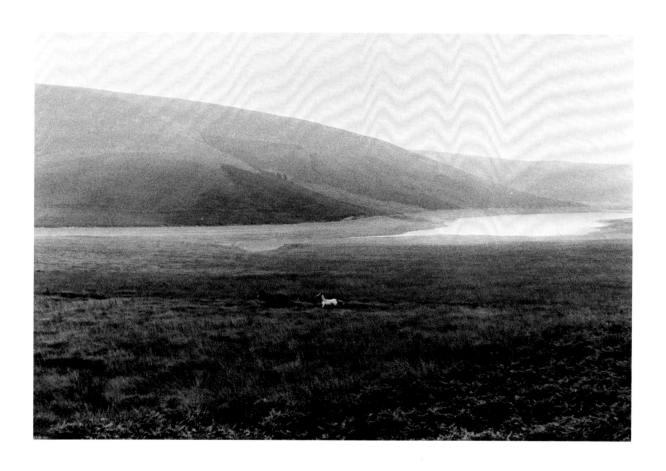

39 Elan Valley, Wales 1971

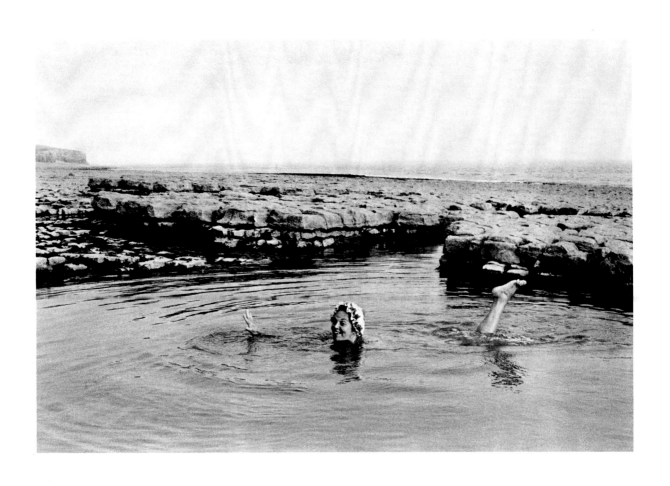

40 Llantwitt Major, Wales 1971

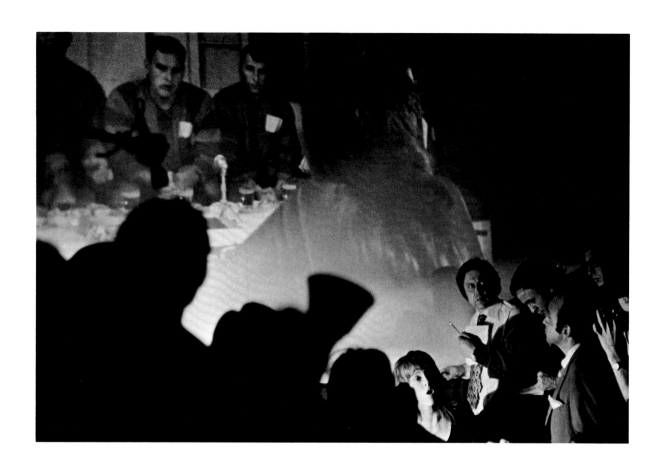

41 Paris, France 1972

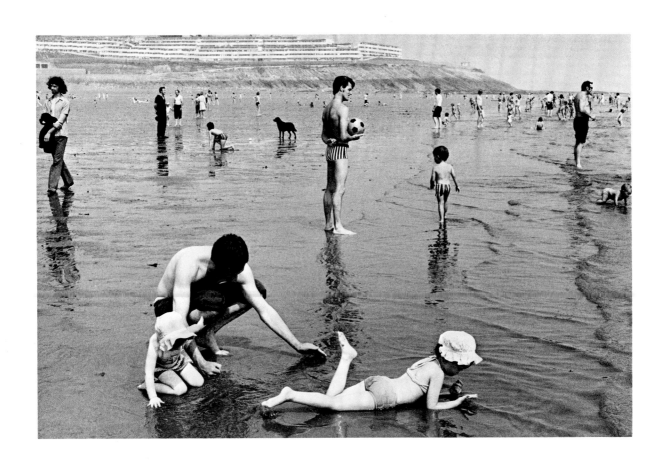

42 Barry Island, Wales 1973

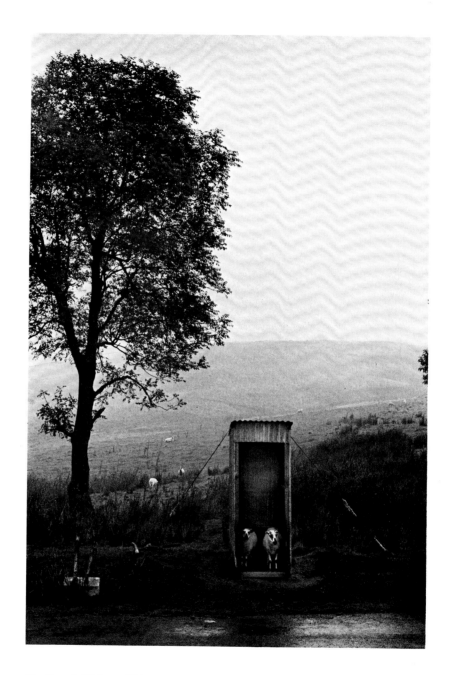

43 Epynt, Wales 1973

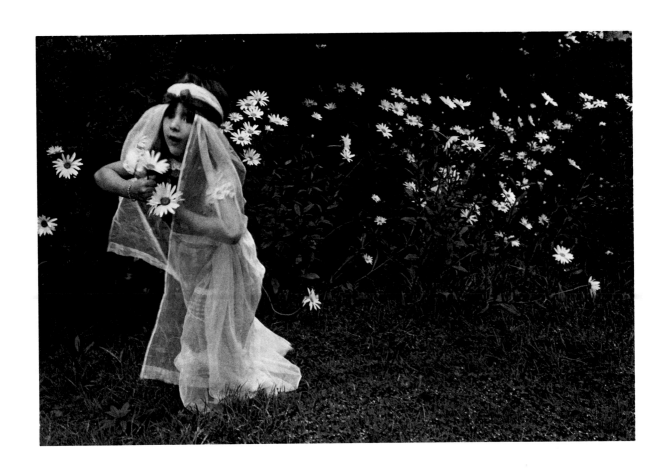

44 Abertillery, Wales 1974

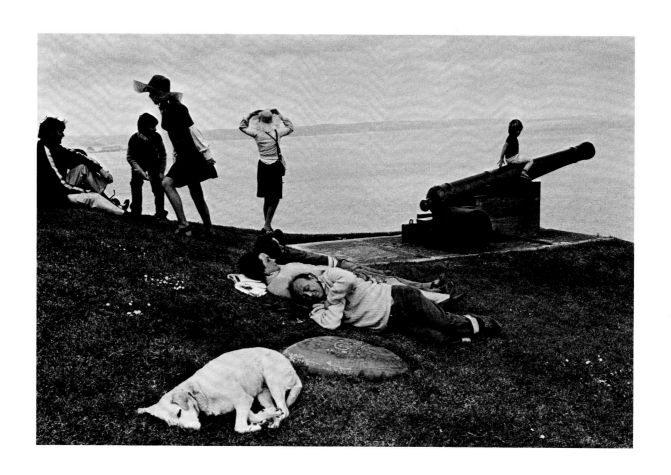

45 Tenby, Wales 1974

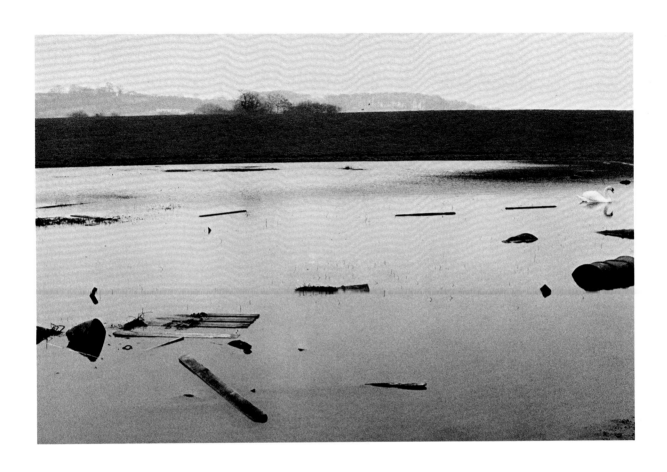

46 Cardiff, Wales 1974

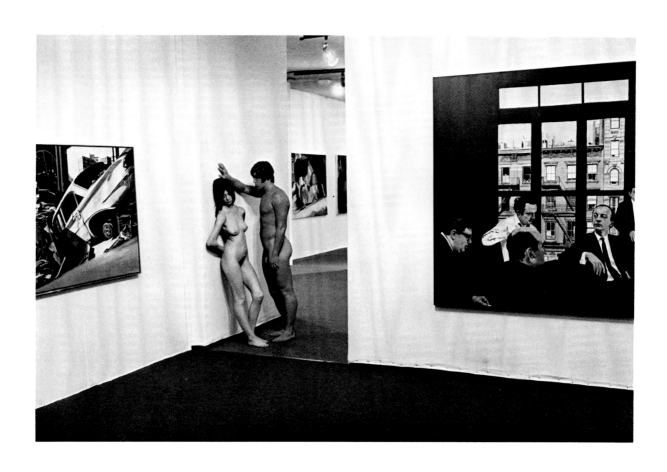

47 Paris, France 1974

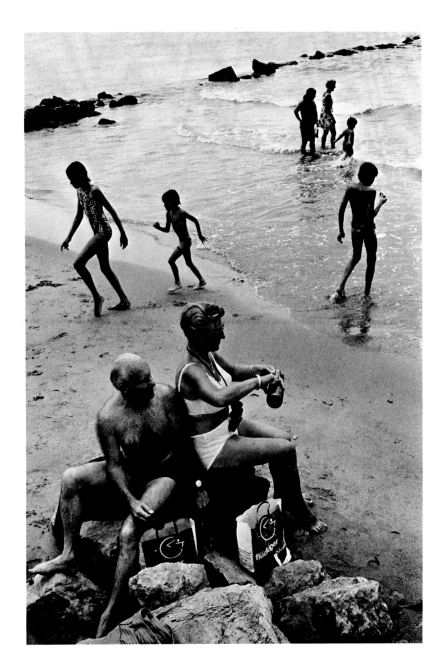

48 Stes. Maries de la Mer, France 1976

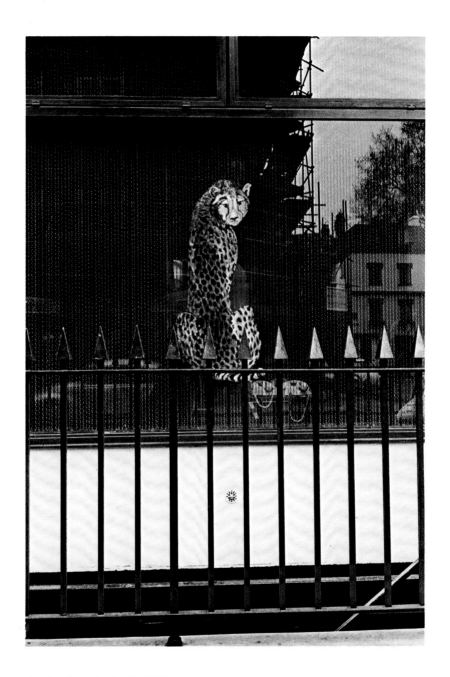

49 London, England 1976

Details of the Plates

1 The Hungarian Revolution – A Freedom fighter, during a lull in the bloodshed.
2 The Partisan Coffee-Bar in central London, the meeting place of left-wing activists of the period.
3 The annual Bank Holiday Fair on Hampstead Heath.
4 A child recently confirmed expresses her feelings immediately after the service.
5 Theatrical partygoers.
6 Pop concert audience shows signs of religious fervour whilst listening to the Beatles.
7 The Sisters of Mercy from Shepherds Bush perform the sad task of looking after the old who are near to death.
8 The Caledonian Ball – a socialite 'Scots in London' event.
9 Waiting to be asked to dance at the Hammersmith Palais.
10 Under Twelve Ballroom Dancing Championships, Royal Albert Hall.
11 Old Time Dancing. There are not always enough men so women perform dual roles.
12 Yugoslavian schoolgirl in typical school dress.
13 Winter at the local beach.
14 Clowns from a small travelling circus try to attract an audience for a future show.
15 Young starlets perform for the American Navy during the Film Festival.
16 Tourists walk by a petrified victim of the Vesuvius eruption.
17 Dora Holtzhandler – a 'Naive' painter.
18 At the funeral of Sir Winston Churchill.
10 Soho strip club dressing-room.
20 Soho 'Model'.
21 Hostess in a men's drinking club.
22 Mother and child.
23 The tragedy of Aberfan, where over a hundred children in the apparent safety of their school were buried under the waste of a sliding coal tip.
24 A Hunt Ball.
25 M.G. car owners' Ball.

Biography

David Hurn was born in Redhill in 1934. His early education was in Cardiff, South Wales. Cardiff has always remained the family home. His interest in photography developed while he was at the Royal Military Academy, Sandhurst and in 1955 he left the army to involve himself in taking pictures as a profession. His first mentor was Michael Peto who introduced him to the agency Reflex where he gained a sound grounding in news photography. His first major project was a freelance coverage of the Hungarian Revolution; the results being extensively published. Since then he has travelled photographing for most of the world's leading magazines. He has also worked at the highest levels in fashion, film, advertising and industrial still photography.

In 1967 David Hurn was invited and joined Magnum Photos – the international co-operative of photographers. In 1971 he received an award from the Welsh Arts Council 'for outstanding merit in a living artist.' He moved to Wales and now spends most of his time working on personal projects. In 1975 Kodak awarded him a Bursary for 'a photographic project of social importance.' During 1979-80 he will be a 'Distinguished Visiting Artist' at Arizona State University, U.S.A. funded by a United Kingdom-United States Bicentennial Arts Fellowship.

As well as taking photographs David Hurn has been very active in support of the medium. In 1971 he worked with the editor Bill Jay in an advisory capacity on the magazine Album. From 1972 until 1977 he was a member of the Arts Council of Great Britain's Photography Committee and spent two years on the Art Panel. In 1973 he became head of the school of Film and Photography at Gwent College of Higher Education in Newport soon setting up the separate school of Documentary Photography. He has lectured widely, taught at workshops in Britain and abroad and has been the subject of three television documentaries.

Selected Individual Exhibitions

1971 SERPENTINE GALLERY, London
1973 BIBLIOTHEQUE NATIONALE, Paris
 NEIKRUG GALLERY, New York
1974 NATIONAL MUSEUM OF WALES, Cardiff
 THE PHOTOGRAPHERS' GALLERY, LONDON
1976 ARLES, France
 ECOLE MUNICIPALE DES ARTS DECORATIFS, Strasbourg
1977 FNAC ETOILE, Paris
 MUSEE DU CHATEAU D'EAU, Toulouse
 RHEINISCHES LANDESMUSEUM, Bonn
 STADTBUCHEREI, Stuttgart
1978 CULTURELE RAAD, Leeuwarden
 CANON FOTO GALLERY, Amsterdam
 GALERIA SPECTRUM, Barcelona
 NORTH LIGHT GALLERY, Arizona
1979 SAN CARLOS OPERA HOUSE, Lisbon
 MIDLAND GROUP GALLERY, Nottingham

Selected Group Exhibitions

1971 PERSONAL VIEWS, British Council Touring Exhibition
1978 IMAGES DES HOMMES, Group Images Touring Exhibition

Selected Articles on David Hurn

1958 PHOTOGRAPHY Vol. 13, No. 4
1967 CAMERA USER (September)
1971 AMATEUR PHOTOGRAPHER Vol. 143, No. 13
 CREATIVE CAMERA (April) No. 82
 BRITISH JOURNAL OF PHOTOGRAPHY Vol. 118, No. 22
1972 PERSONAL VIEWS British Council Catalogue
 ZOOM, France (November/December)
1974 BRITISH JOURNAL OF PHOTOGRAPHY Vol. 121, No. 48
 CREATIVE CAMERA (December) No. 126
 AMATEUR PHOTOGRAPHER Vol. 150, No. 24
1976 NEWS REPORTER, France (June) No. 5
1977 CATALOGUE, Galerie Municipale en Chateau d'Eau (April/May)
 ZOOM, France (May/June)
 AKTUELLE FOTOGRAFI (November)
1978 CAMERAWORK No. 9